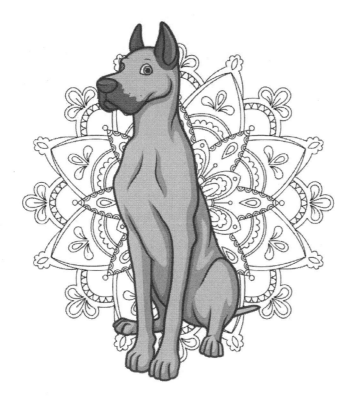

# This Coloring Book Belongs To:

A COLORING BOOK CREATION BY
ORIGINALCOLORINGPAGES.COM

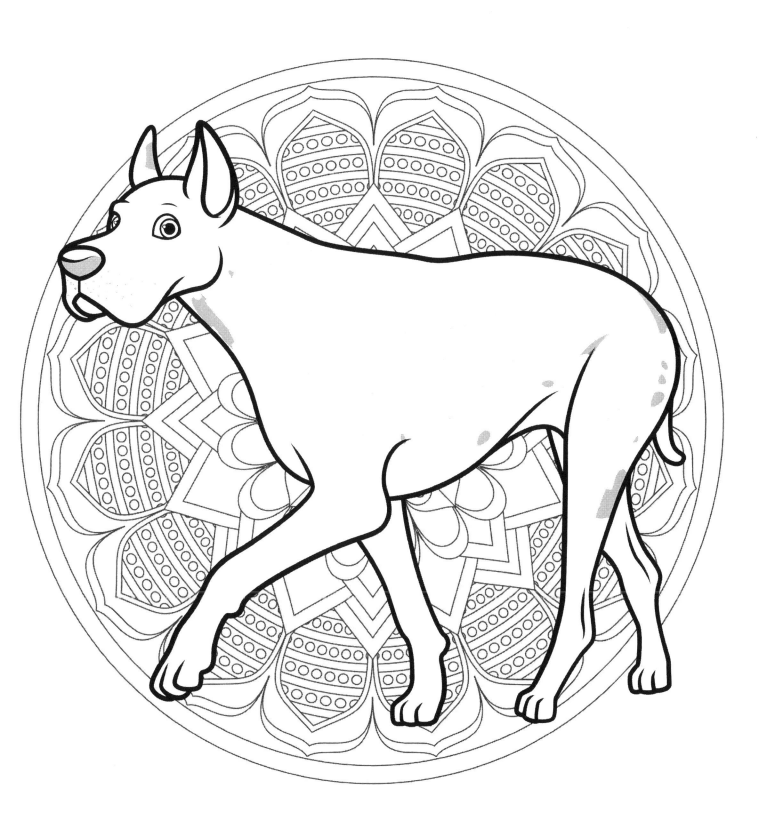

Thanks for the coloring!

Don't Forget to Leave Us a Review on Amazon!

A COLORING BOOK CREATION BY
ORIGINALCOLORINGPAGES.COM

Made in the USA
San Bernardino, CA
04 February 2020